MY COLORS

Written and illustrated by

ORNA

Copyright © 2016 ORNA

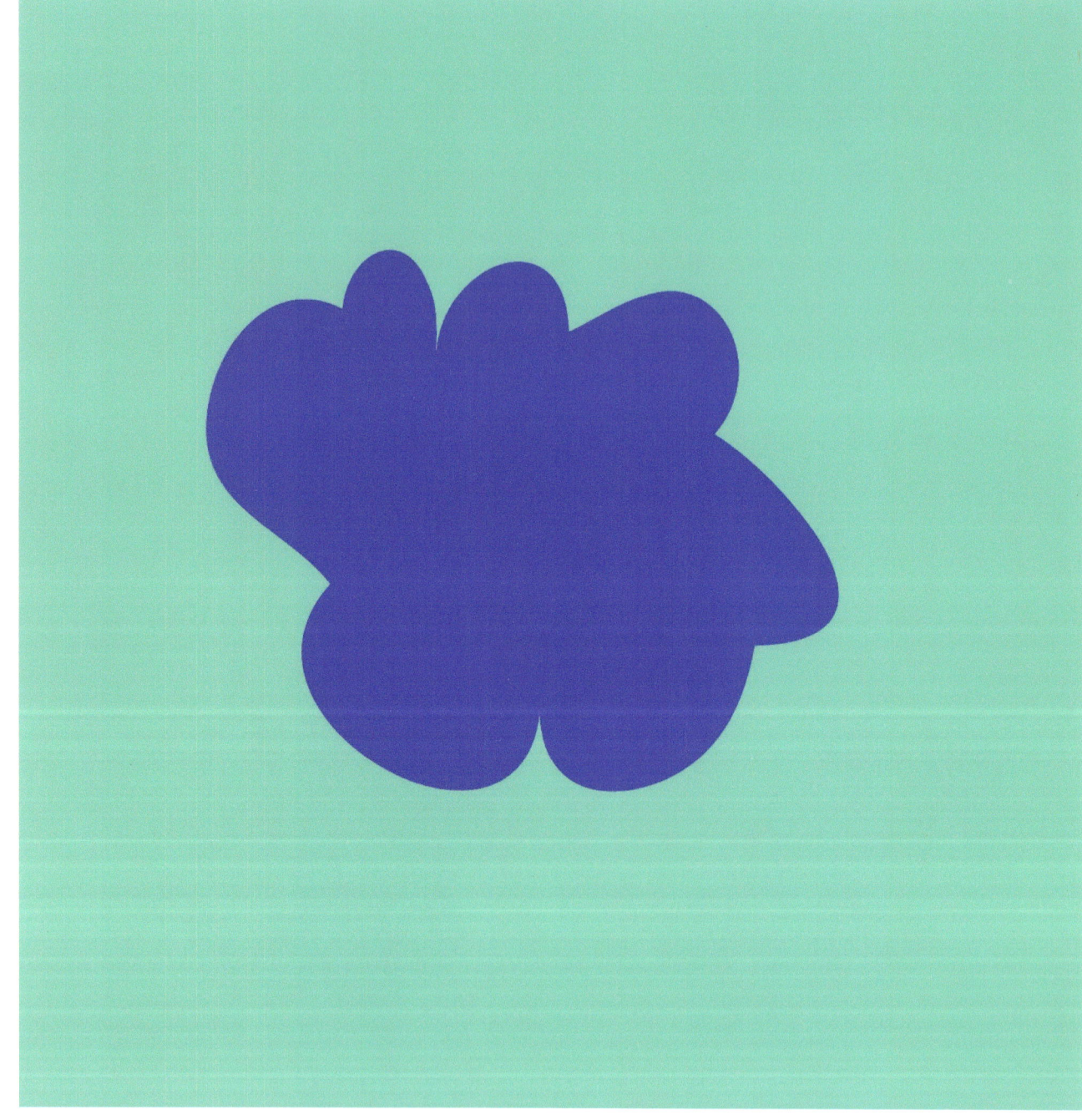

BLUE

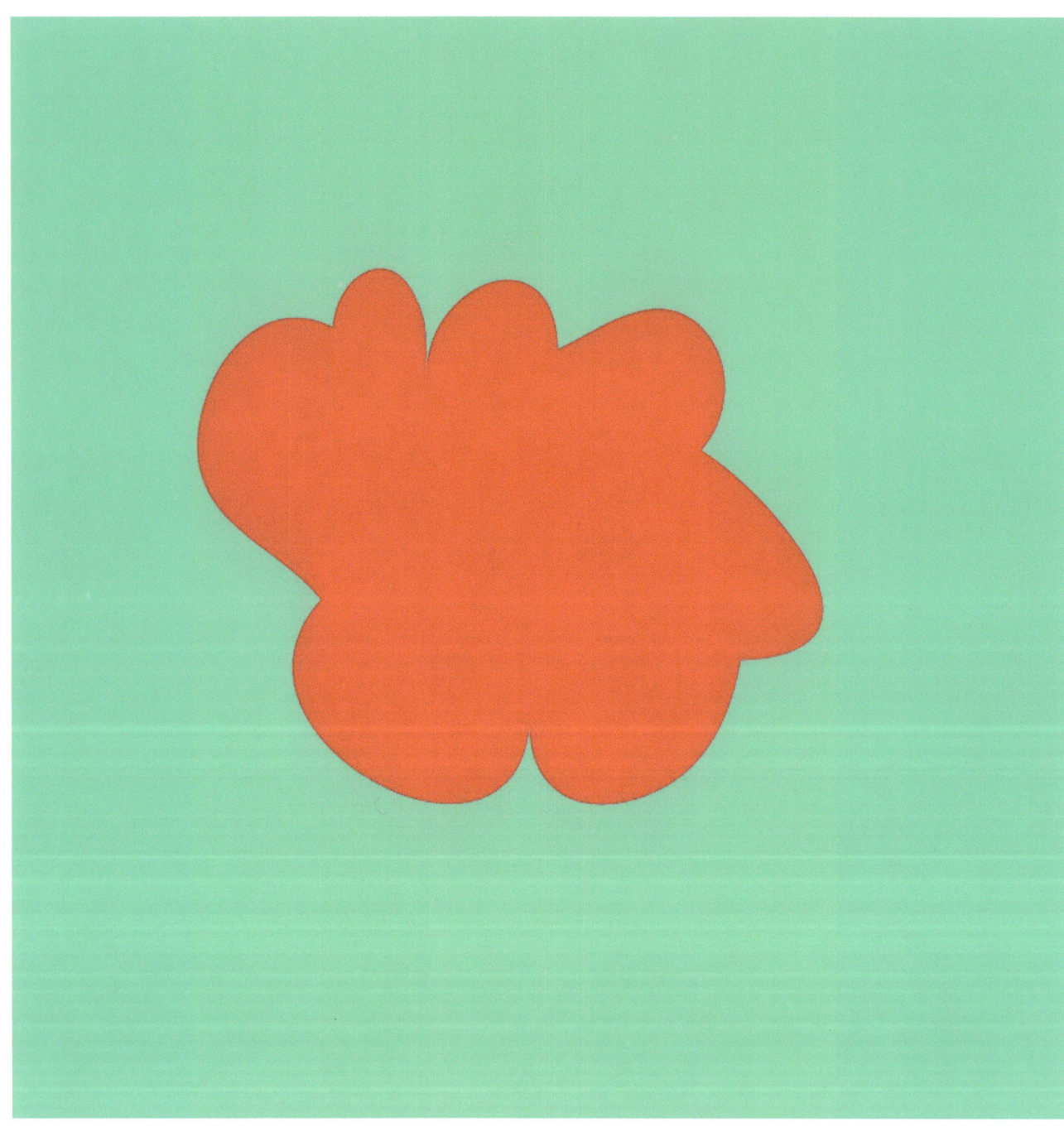

RED

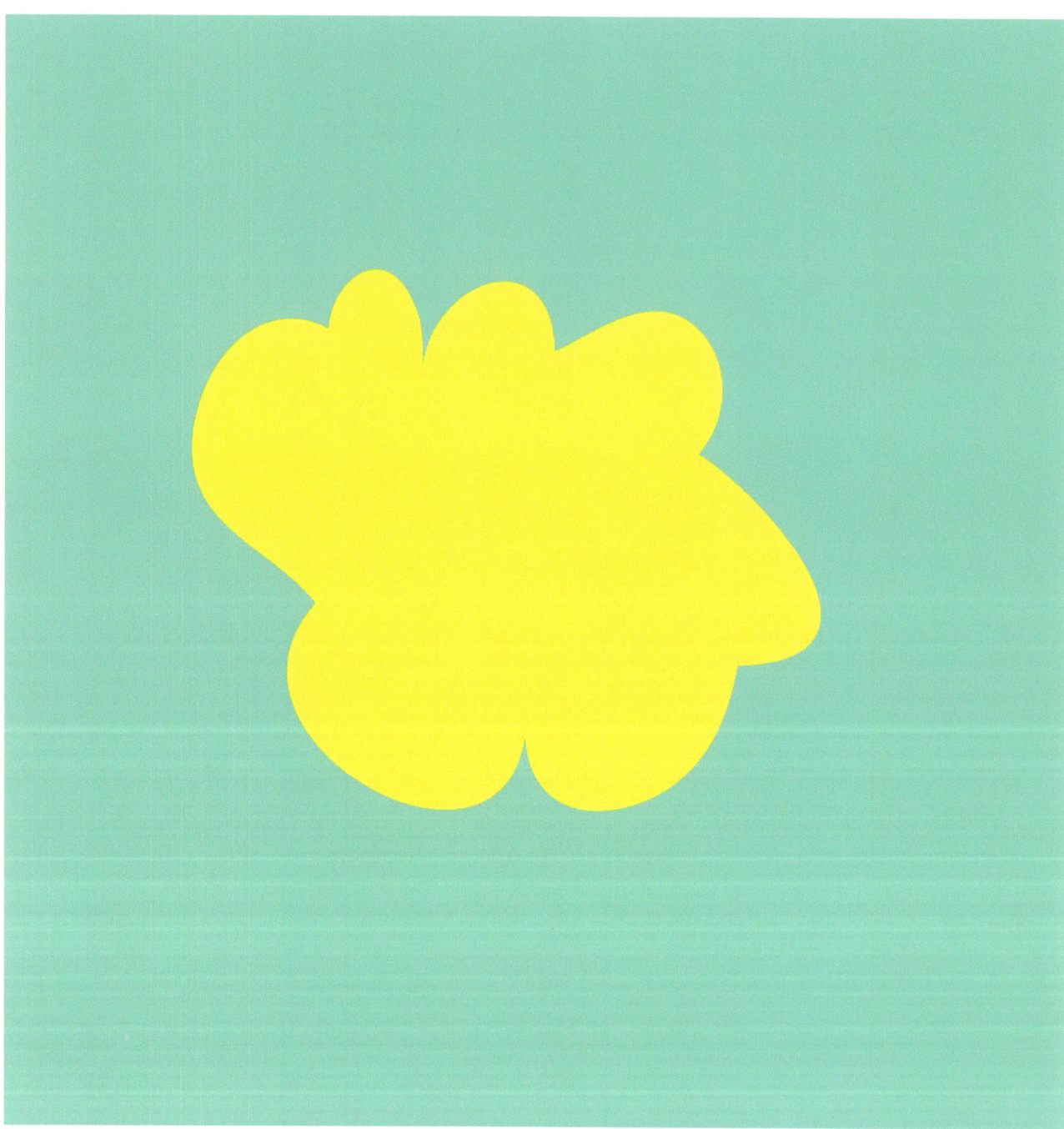

YELLOW

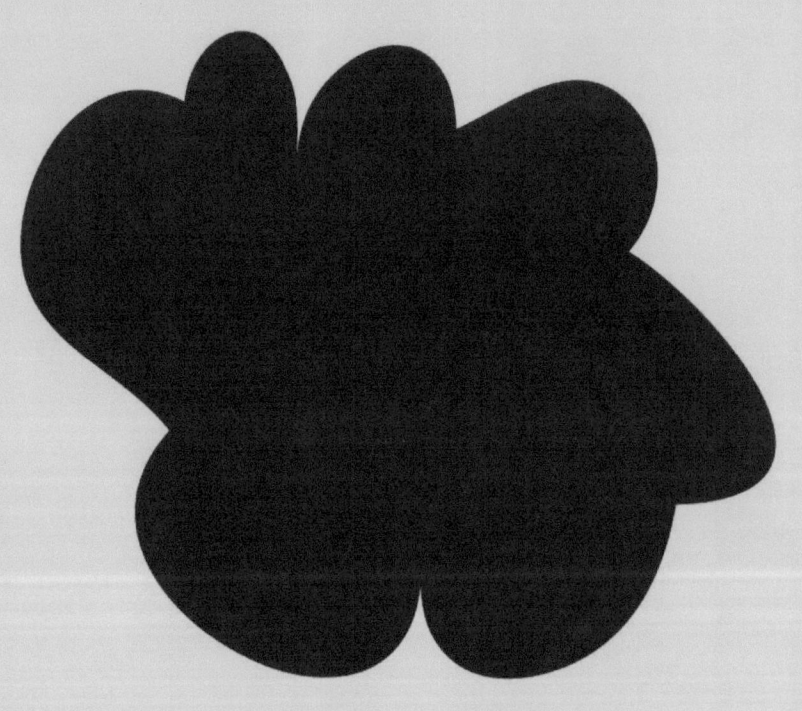

BLACK

WHITE

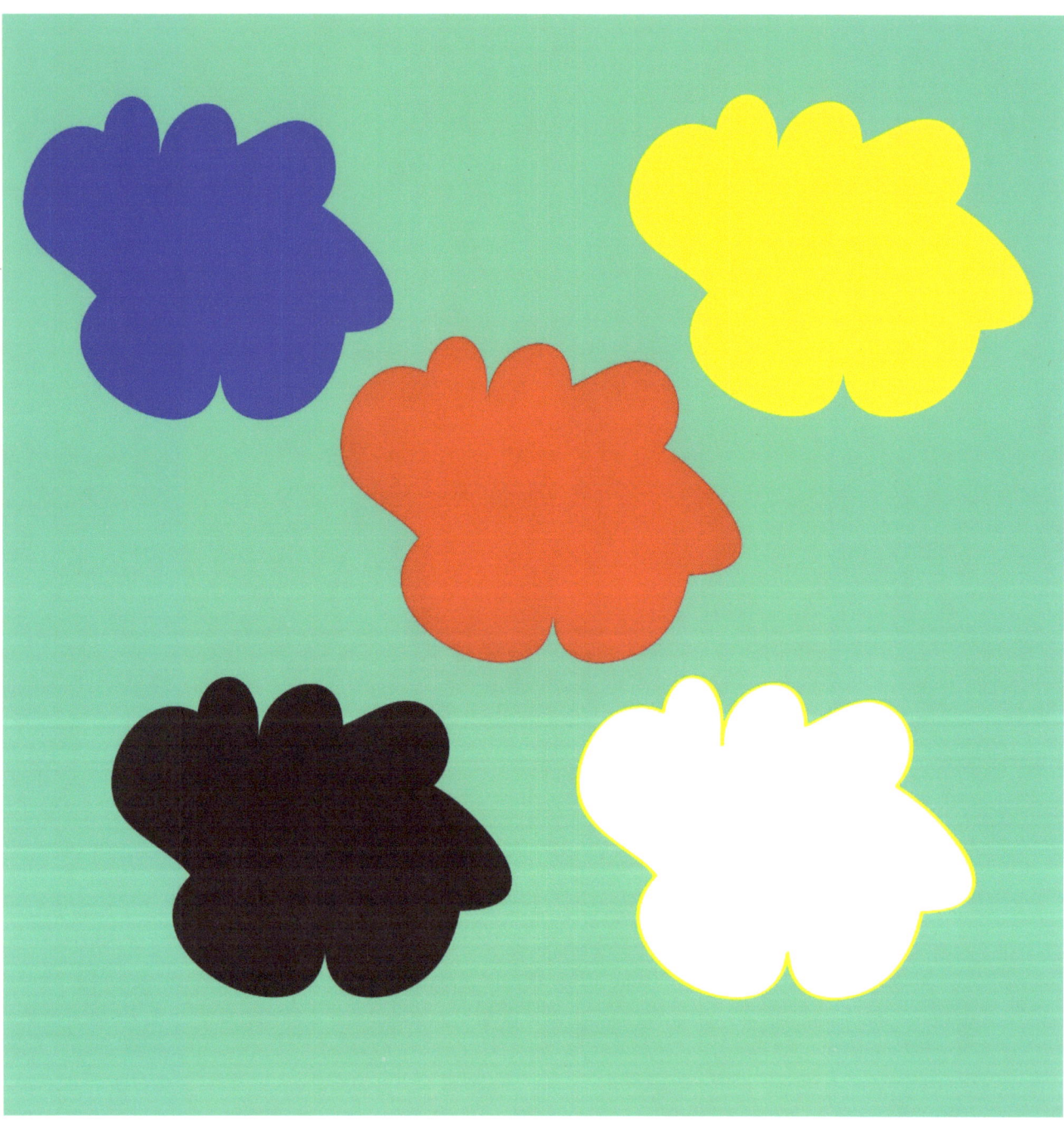

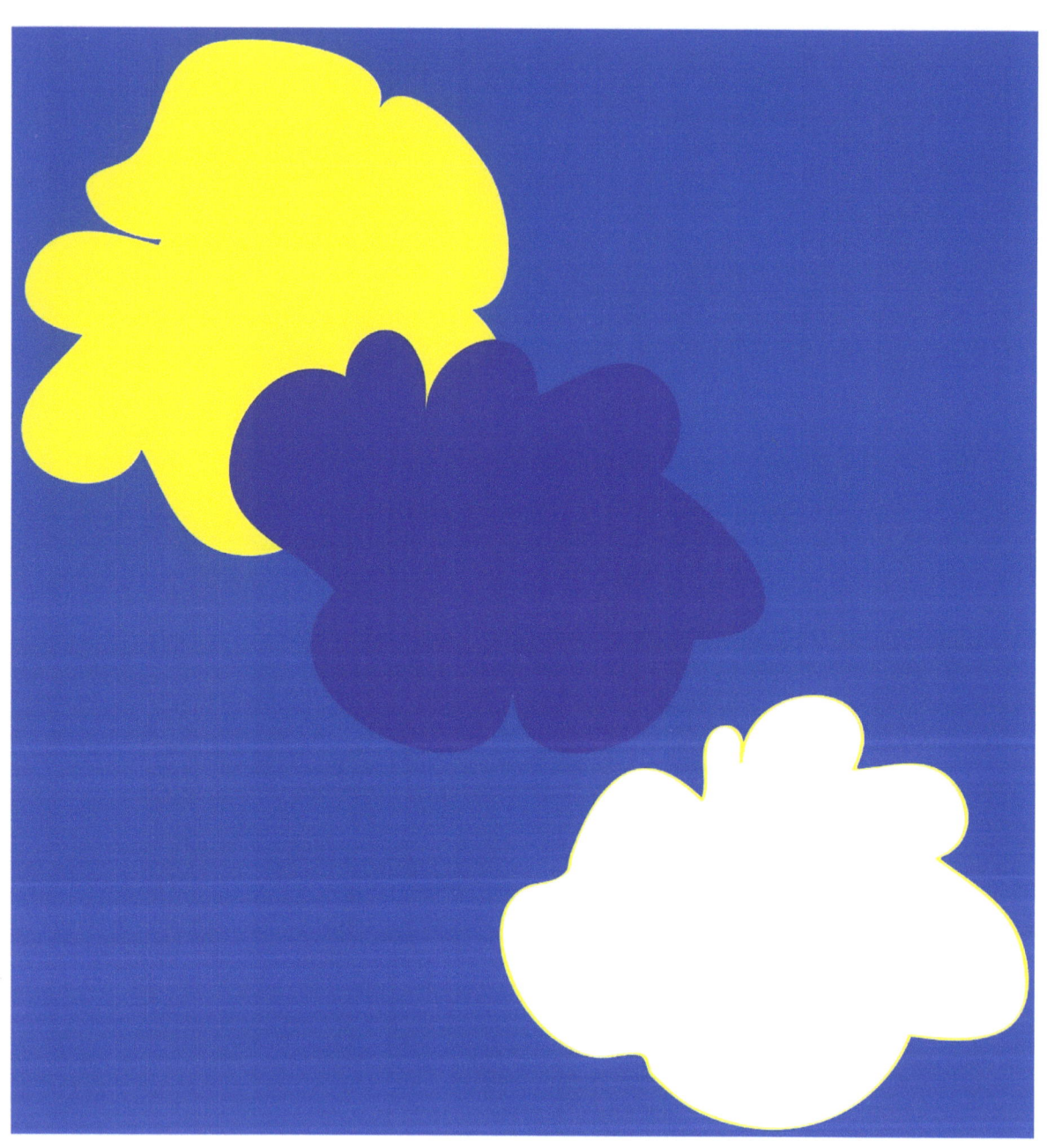

MIX
BLUE
WITH
YELLOW

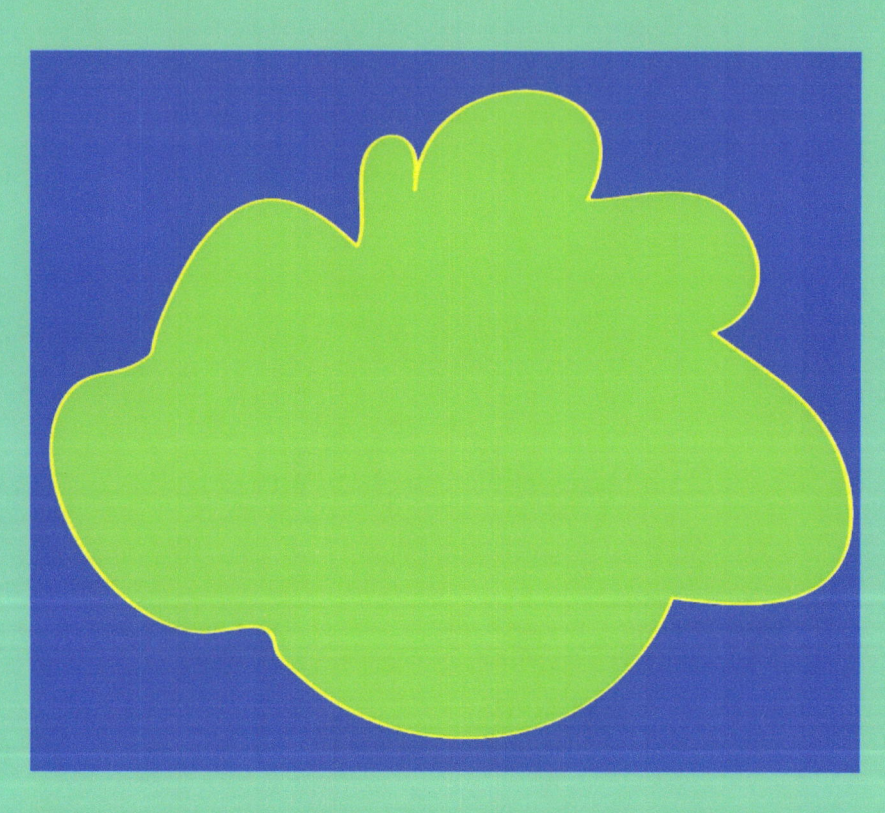

GREEN

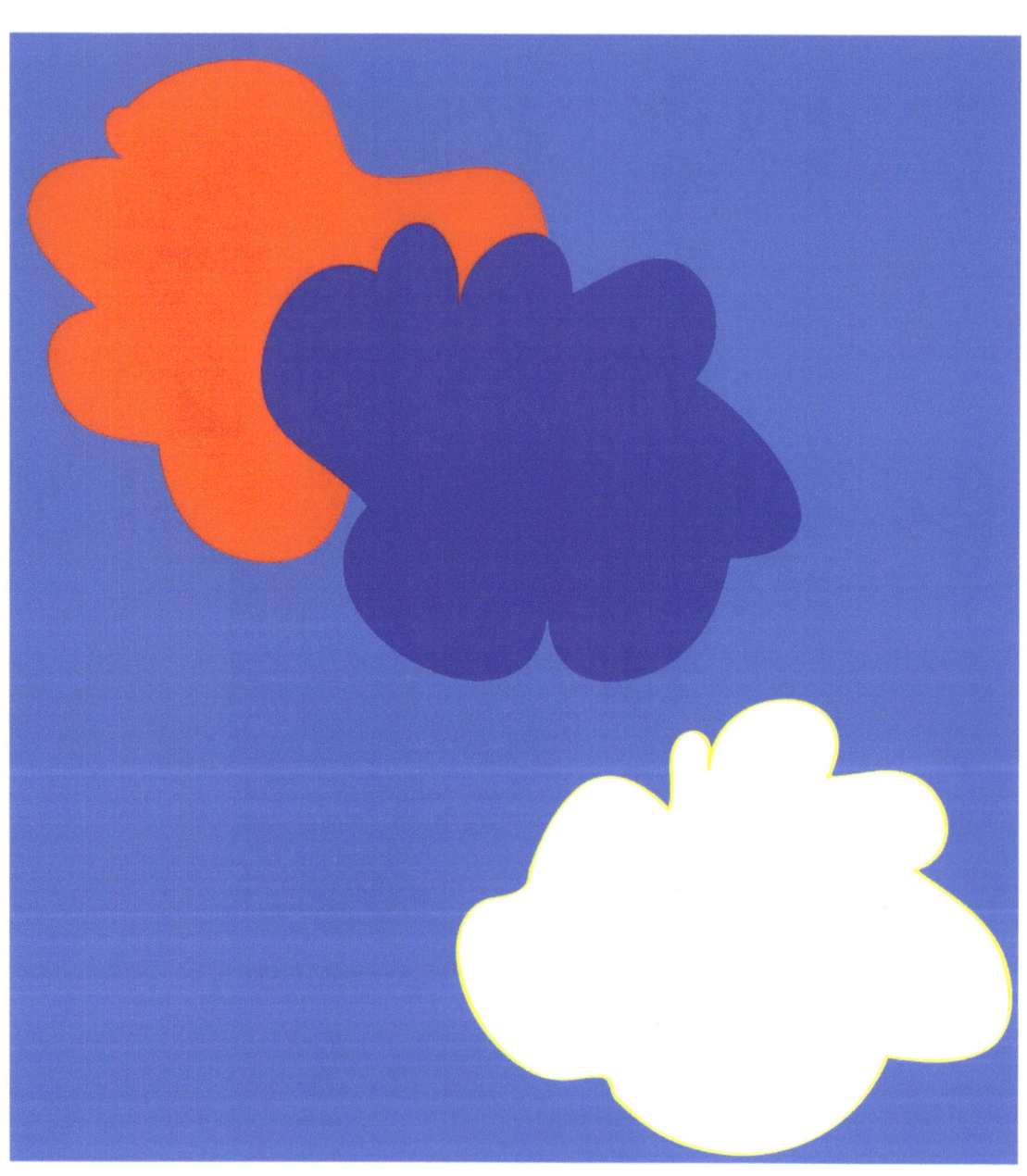

MIX
RED
WITH
BLUE

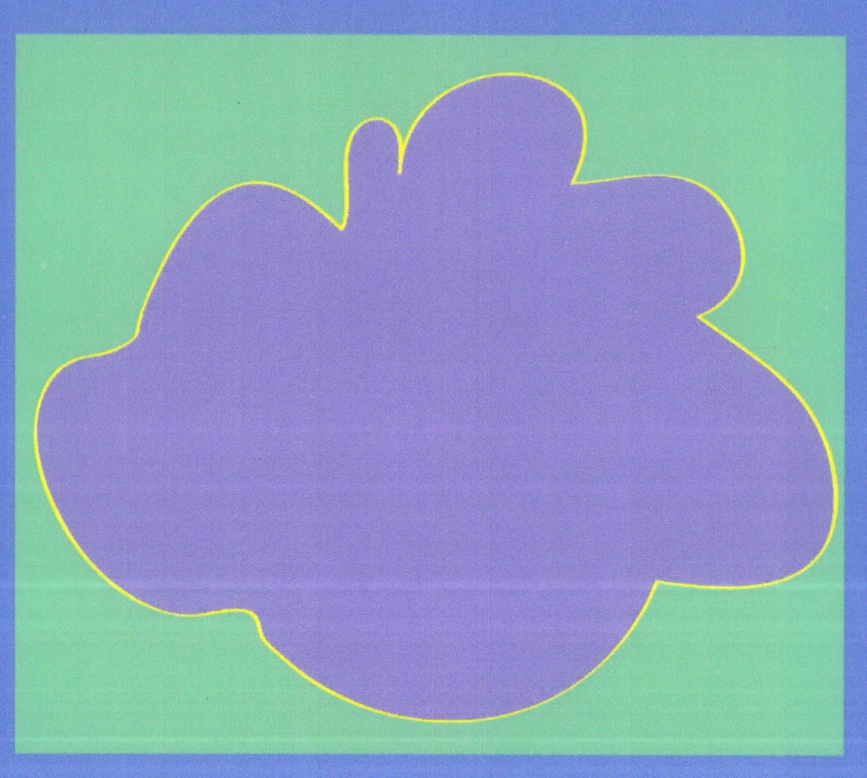

PURPLE

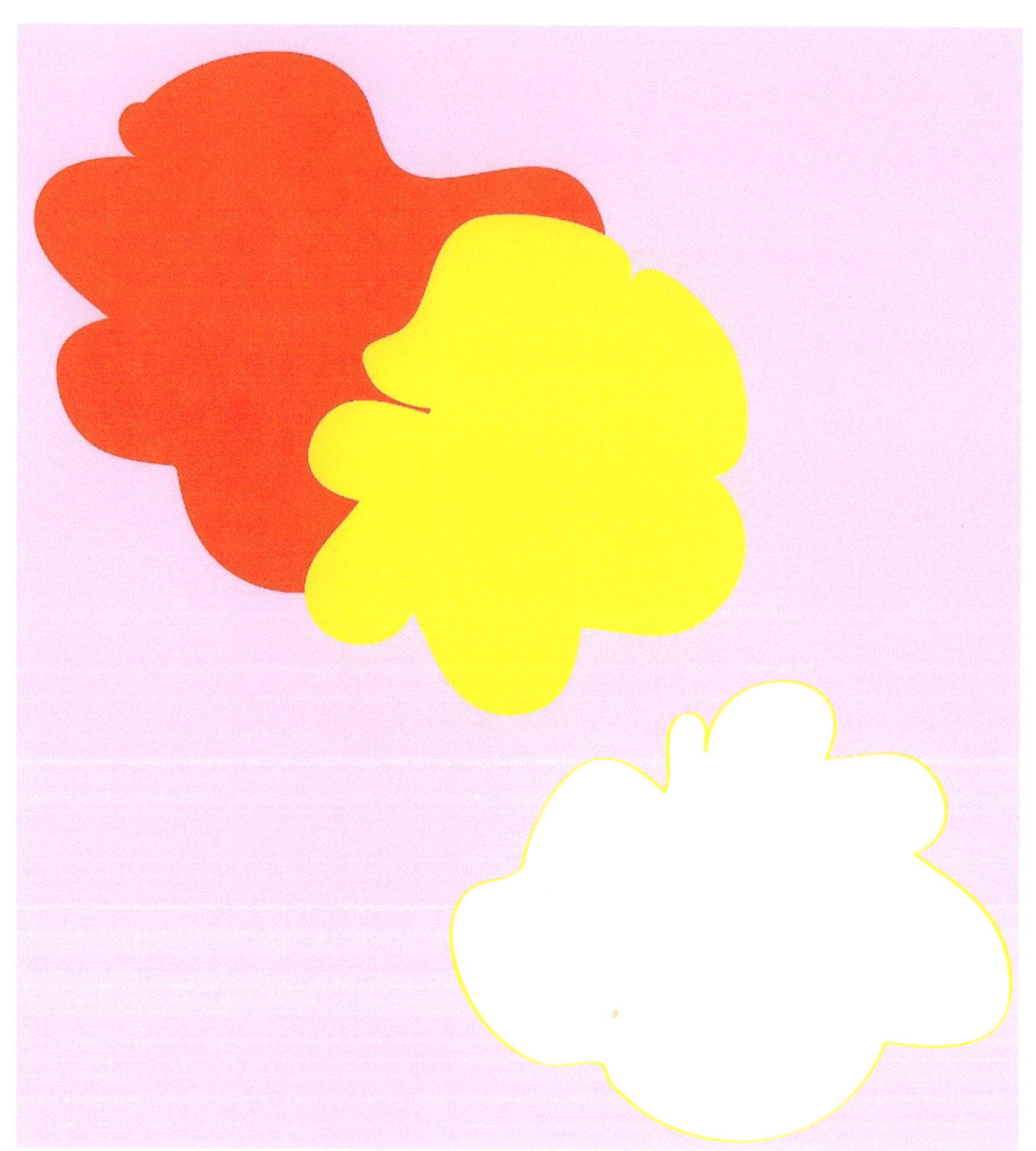

MIX
RED
WITH
YELLOW

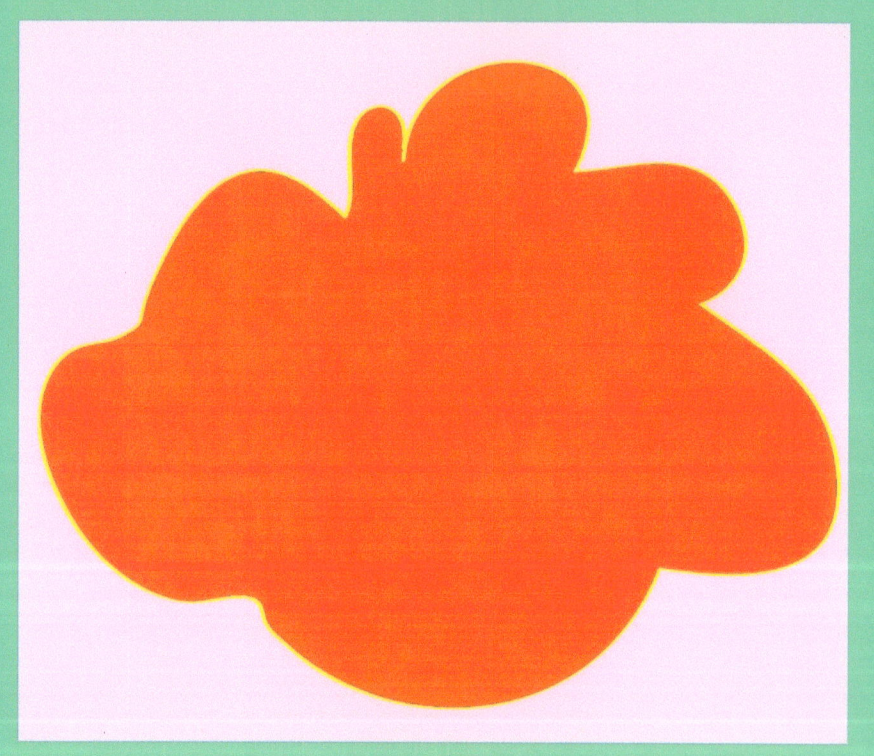

ORANGE

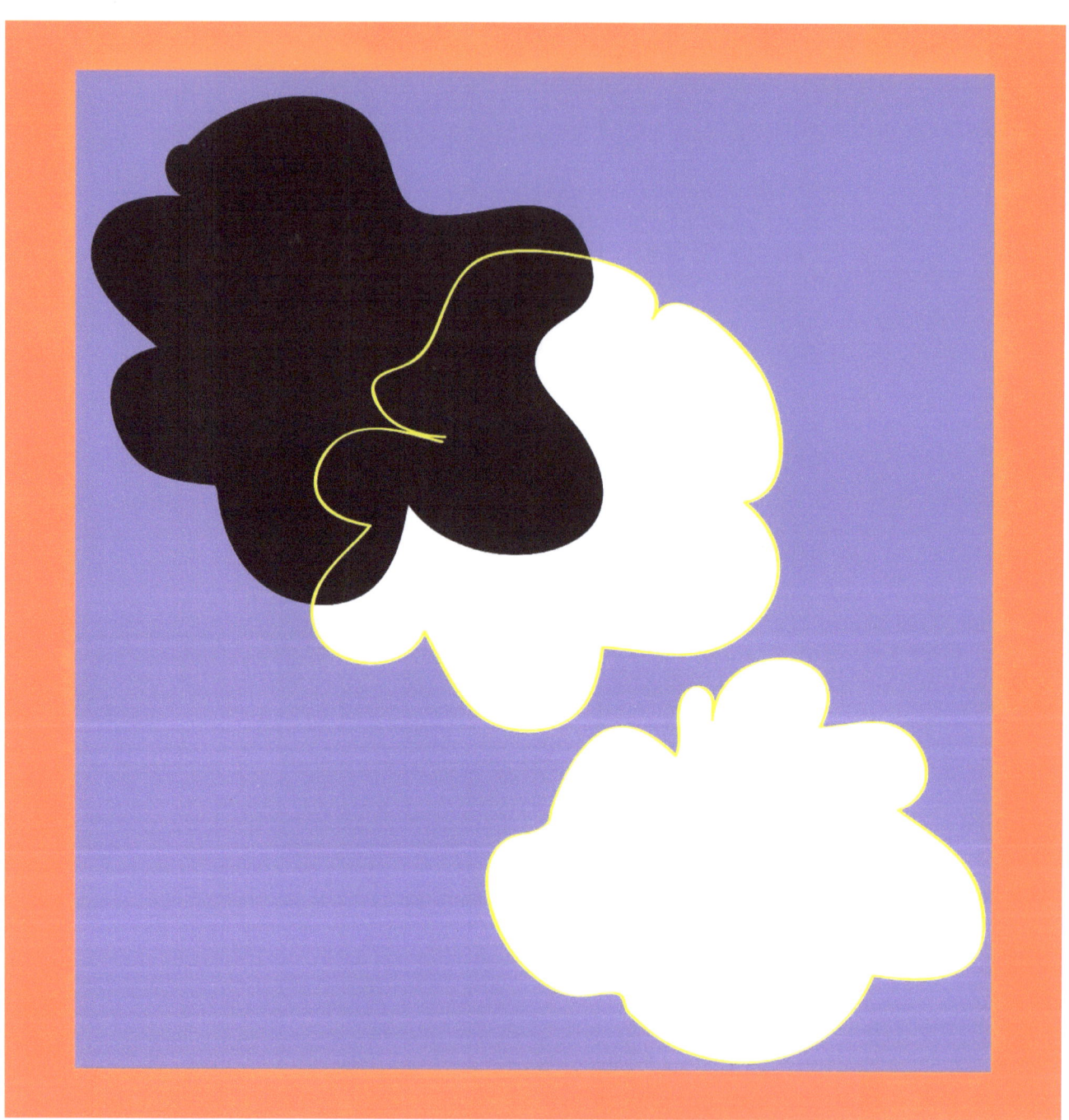

MIX
BLACK
WITH
WHITE

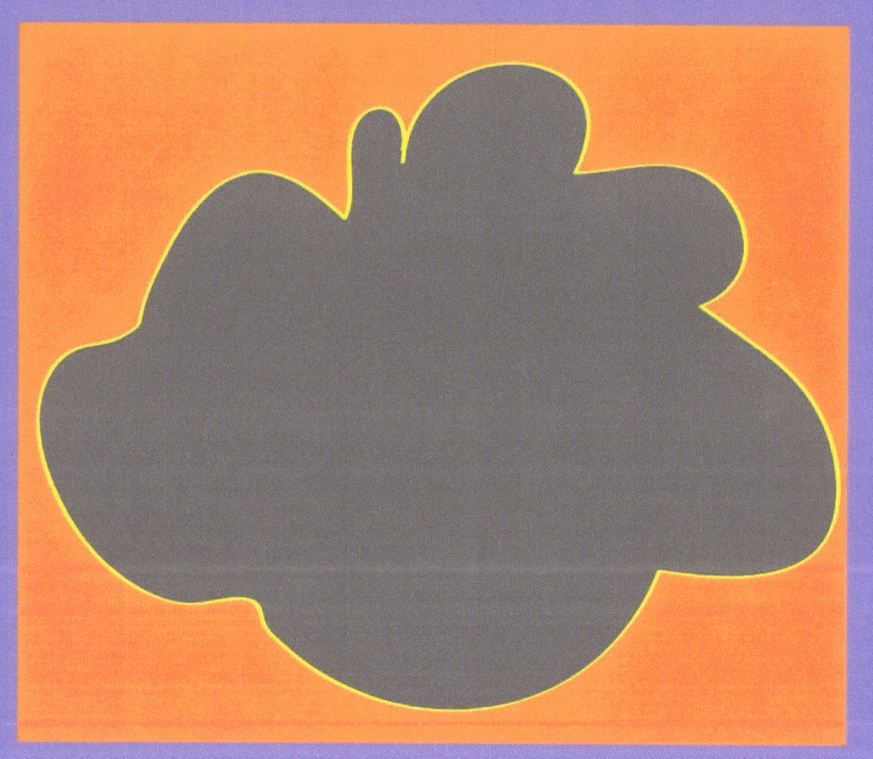

GREY

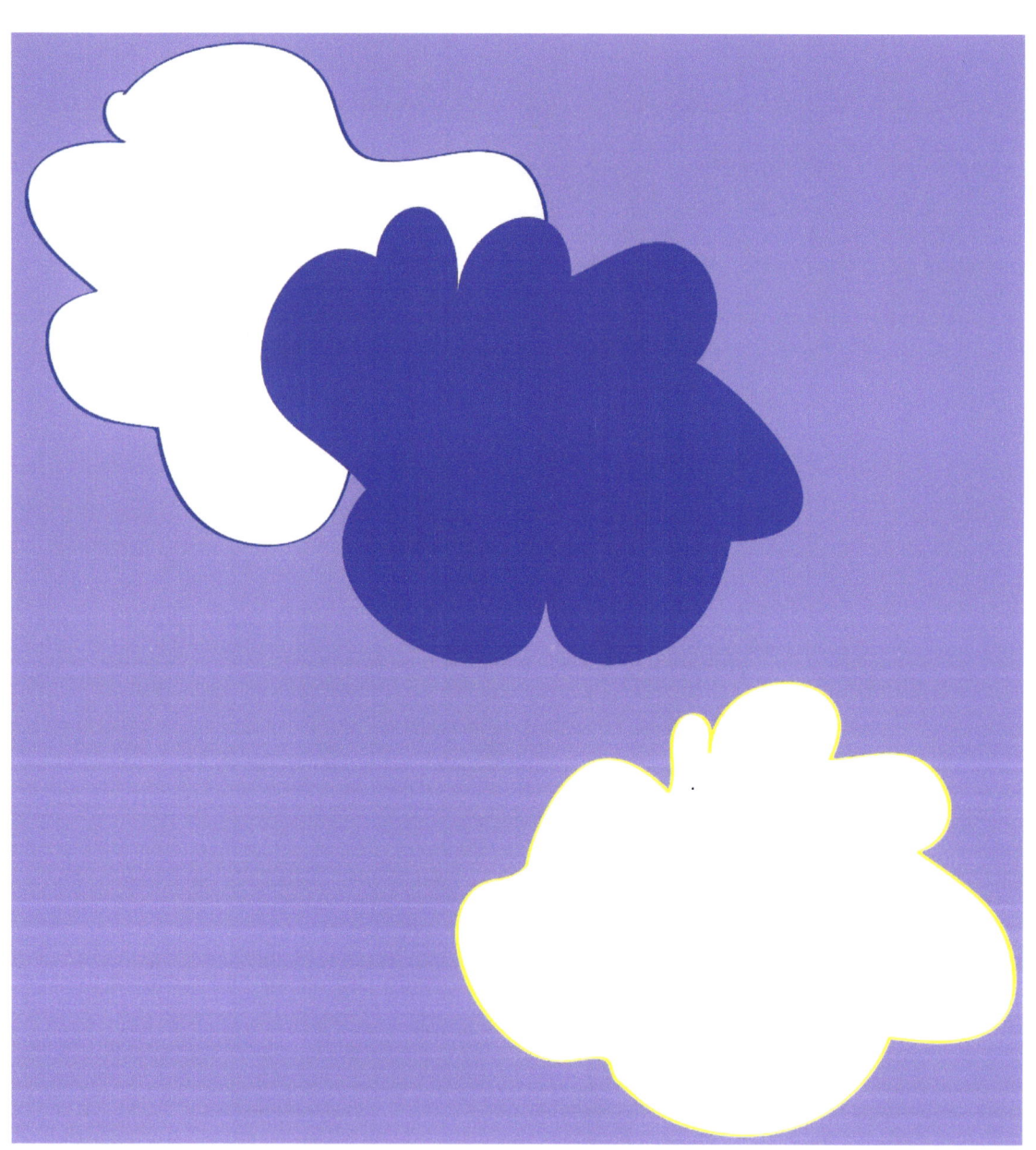

MIX
BLUE
WITH
WHITE

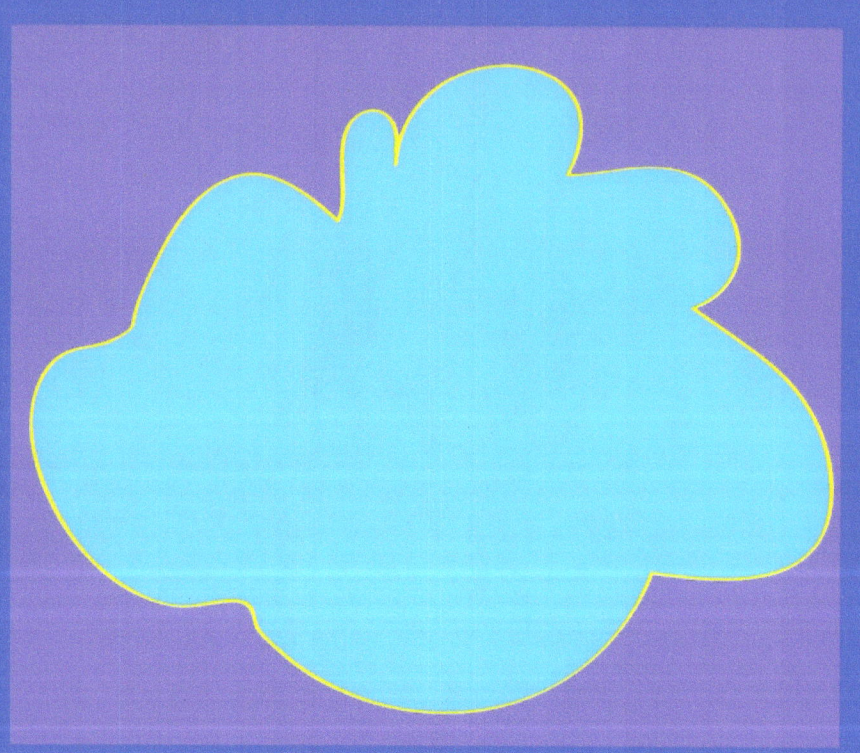

LIGHT BLUE

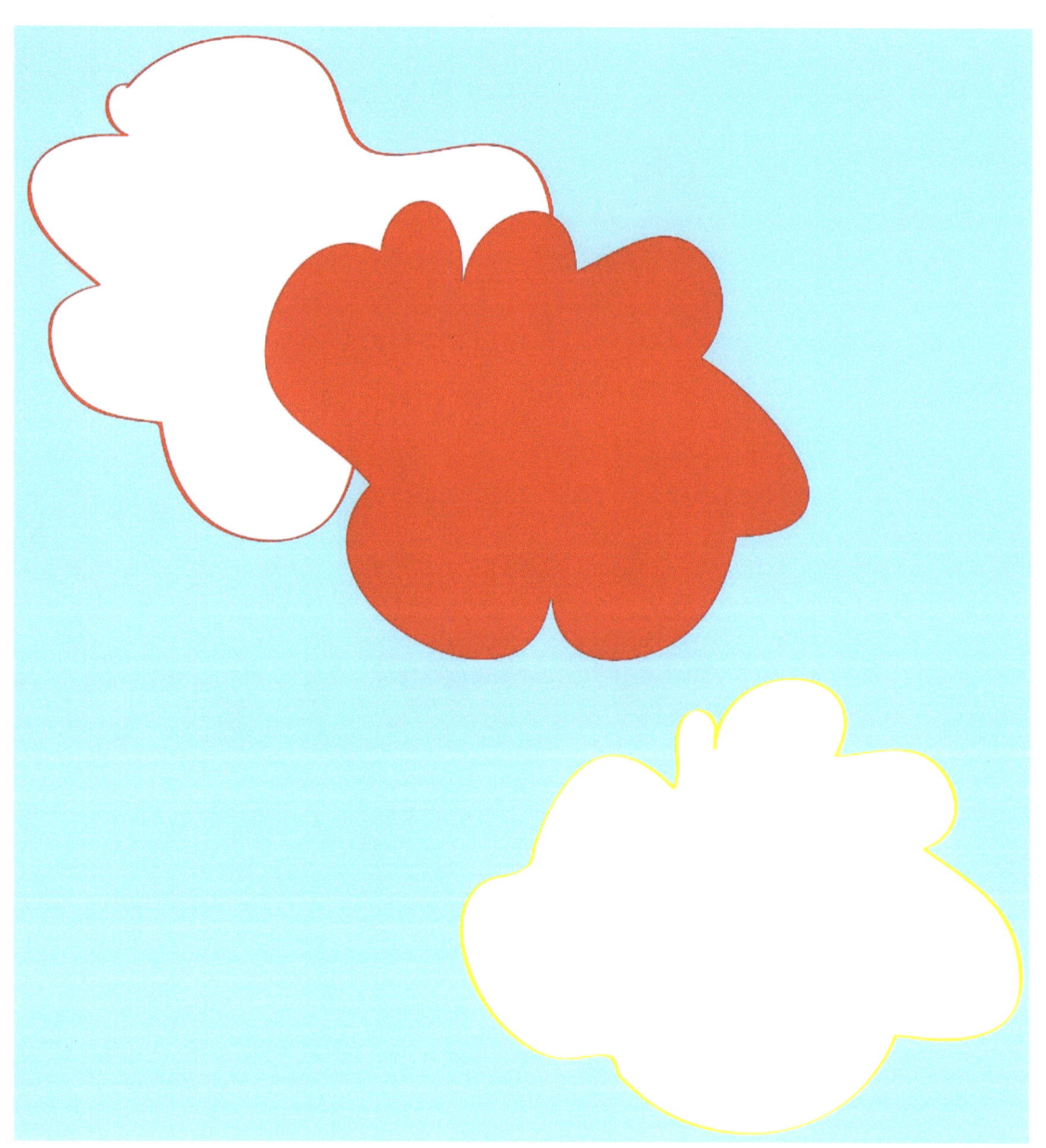

MIX
RED
WITH
WHITE

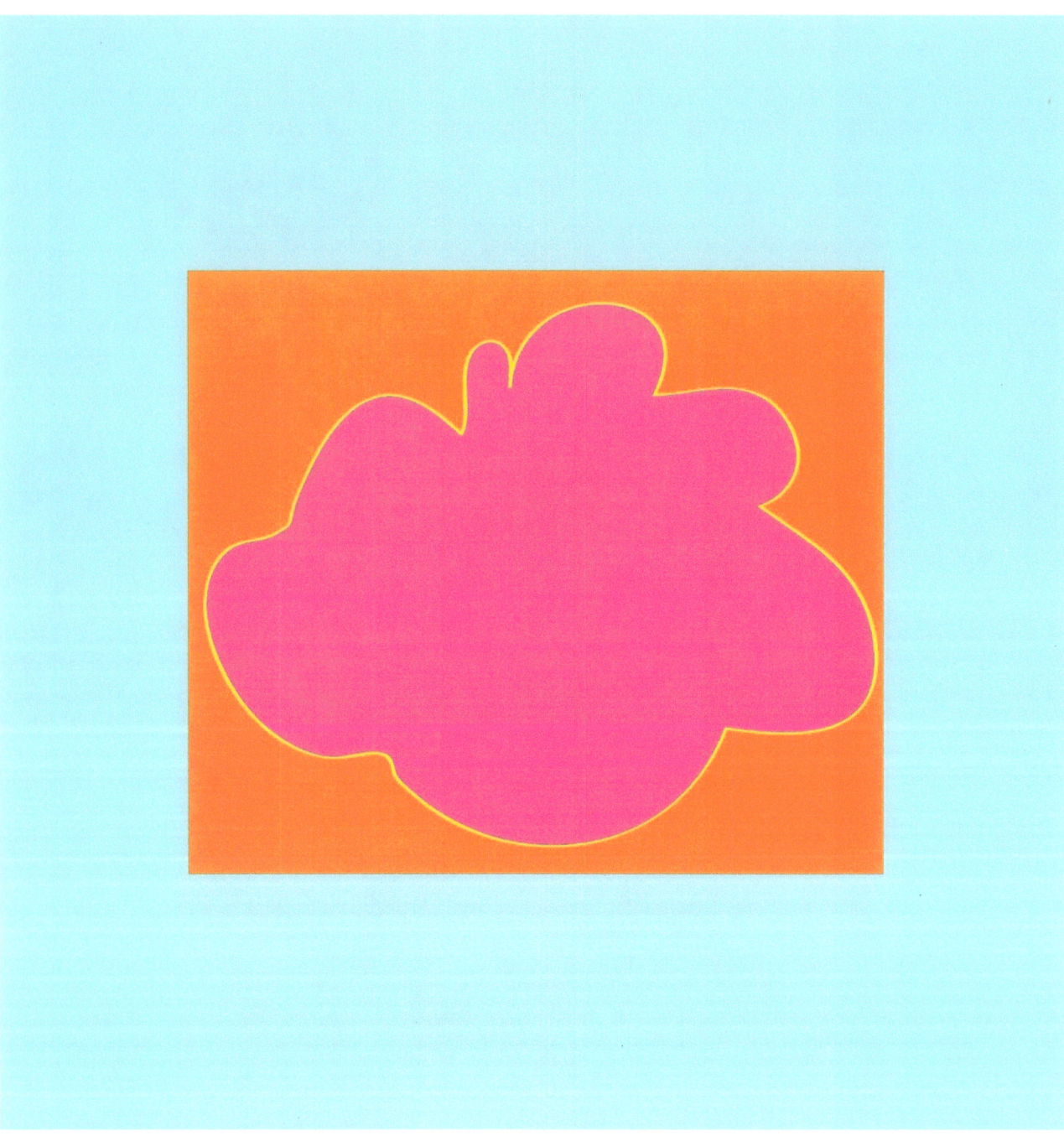

PINK

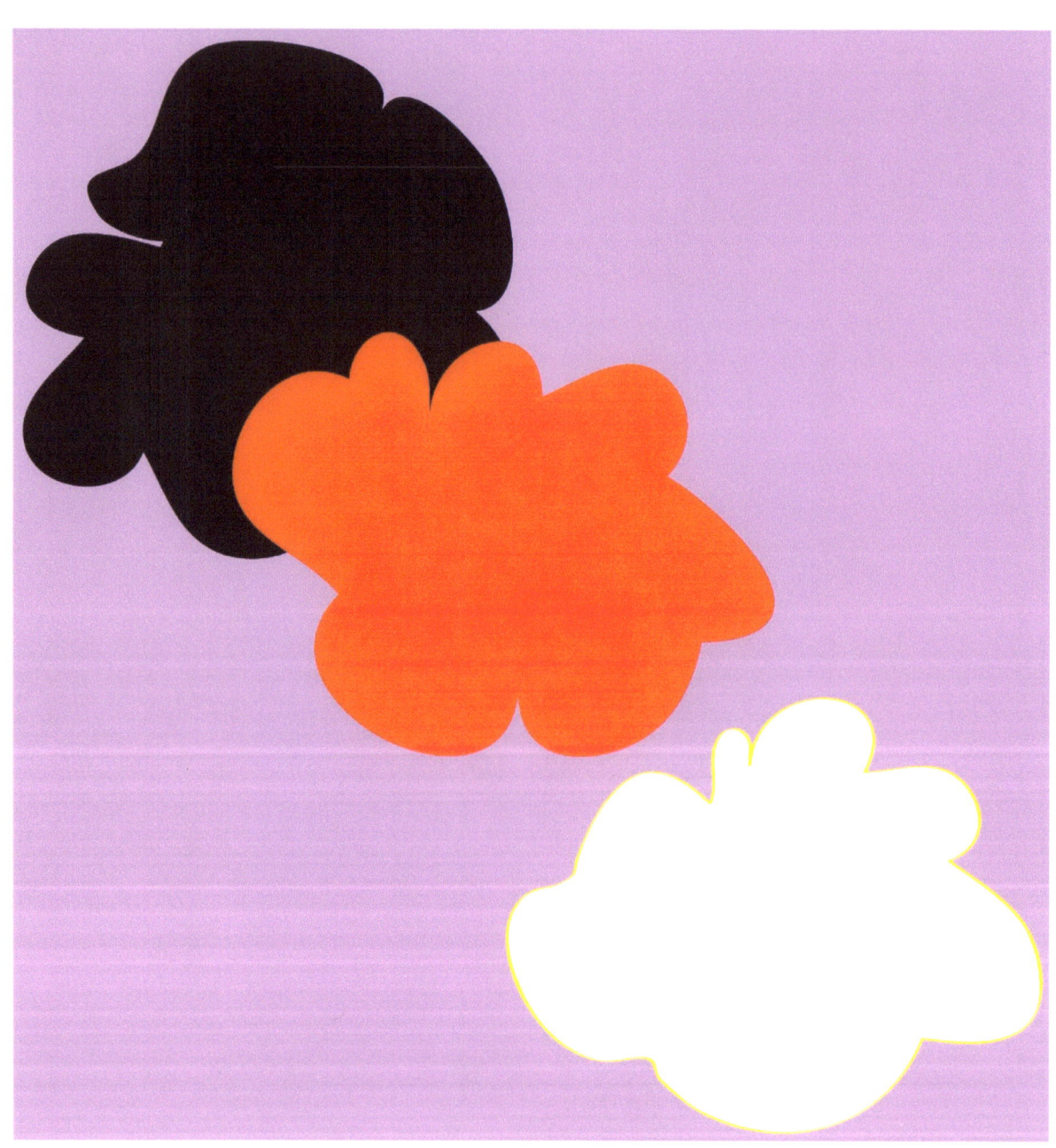

MIX

BLACK

WITH

ORANGE

BROWN

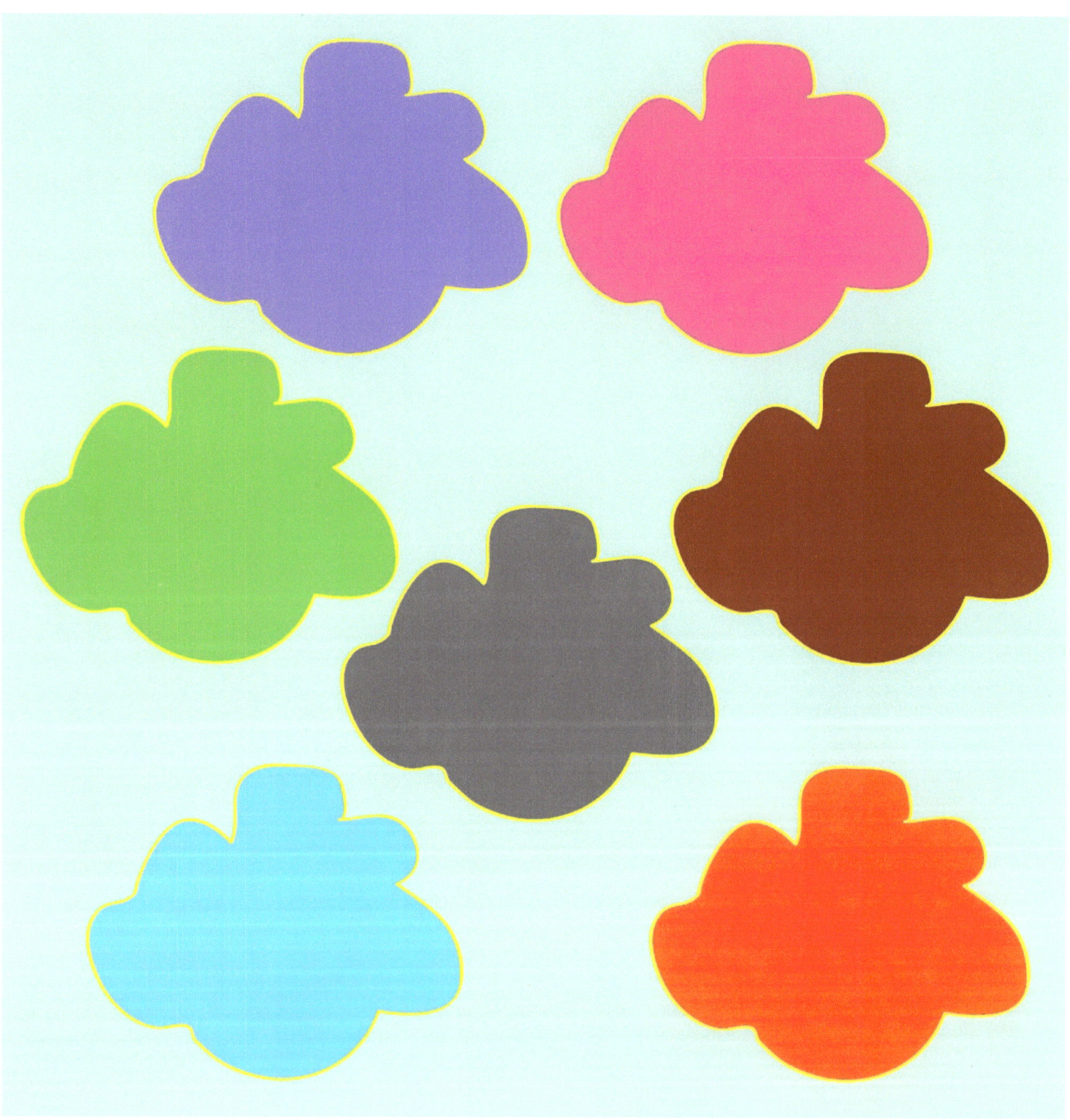

BLUE LIGHT BLUE
RED PINK
YELLOW
BLACK GREY
WHITE
ORANGE
GREEN BROWN
PURPLE

www.ingramcontent.com/pod-product-compliance
Lightning Source LLC
Chambersburg PA
CBHW041317180526
45172CB00004B/1130